THE CRIME OF ART

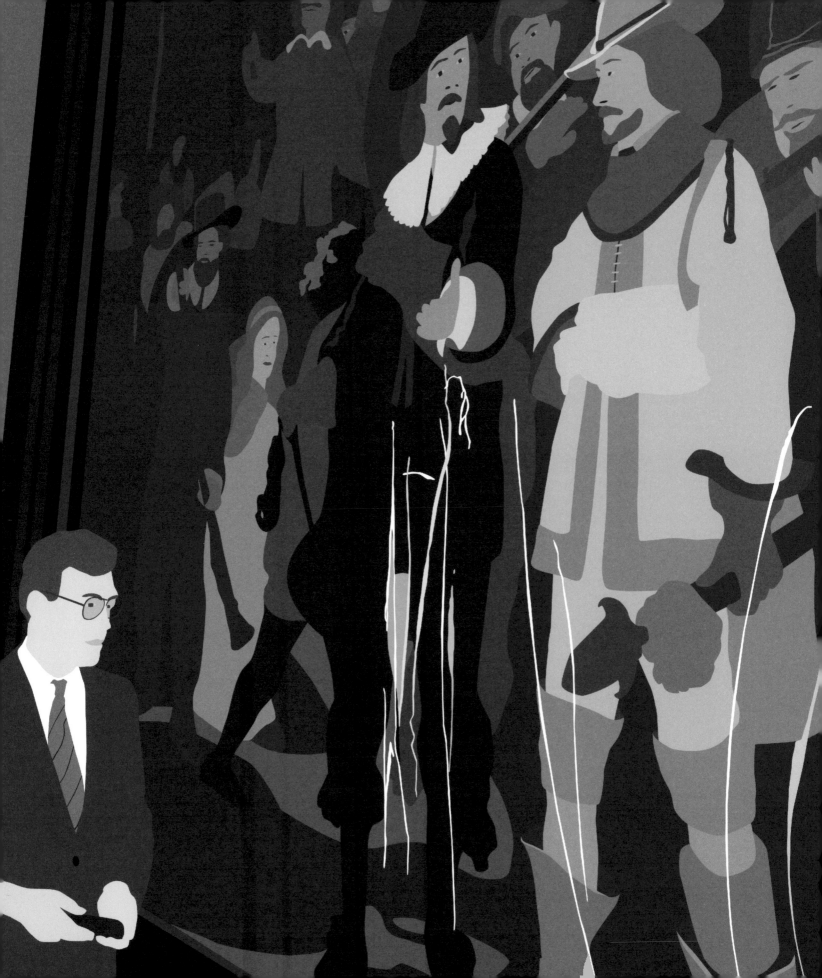

THE CRIME OF ART

Kota Ezawa

RADIUS BOOKS

SITE SANTA FE

MEAD ART MUSEUM

CONTENTS

CHAPTER 1: A Short History of Art and Crime

THE DEATH OF MARAT

Digital Drawing, 2017

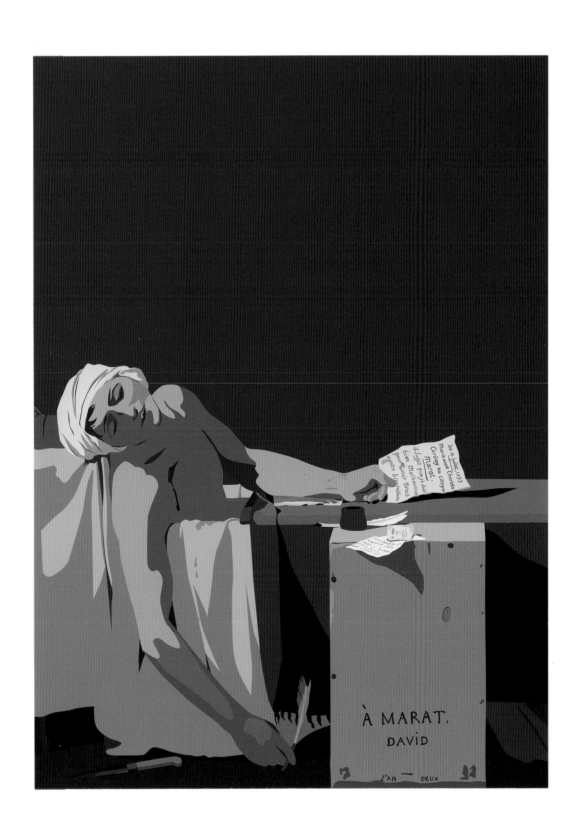

THE UNBEARABLE LIGHTNESS OF BEING

16mm film (color, silent), 1 min., 2005

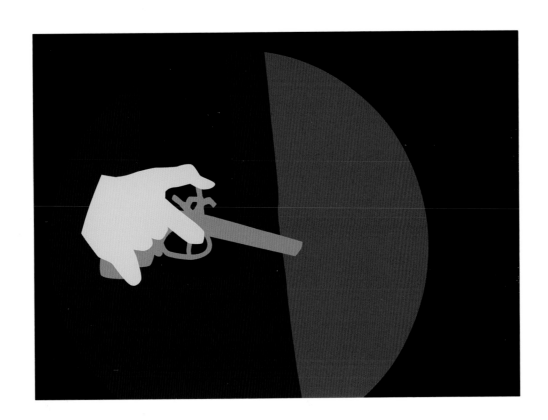

THE UNBEARABLE LIGHTNESS OF BEING

16mm film (color, silent), 1 min., 2005

Installation View
San Francisco Museum of Modern Art, 2010
Photograph by Ian Reeves
Courtesy San Francisco Museum of Modern Art

12

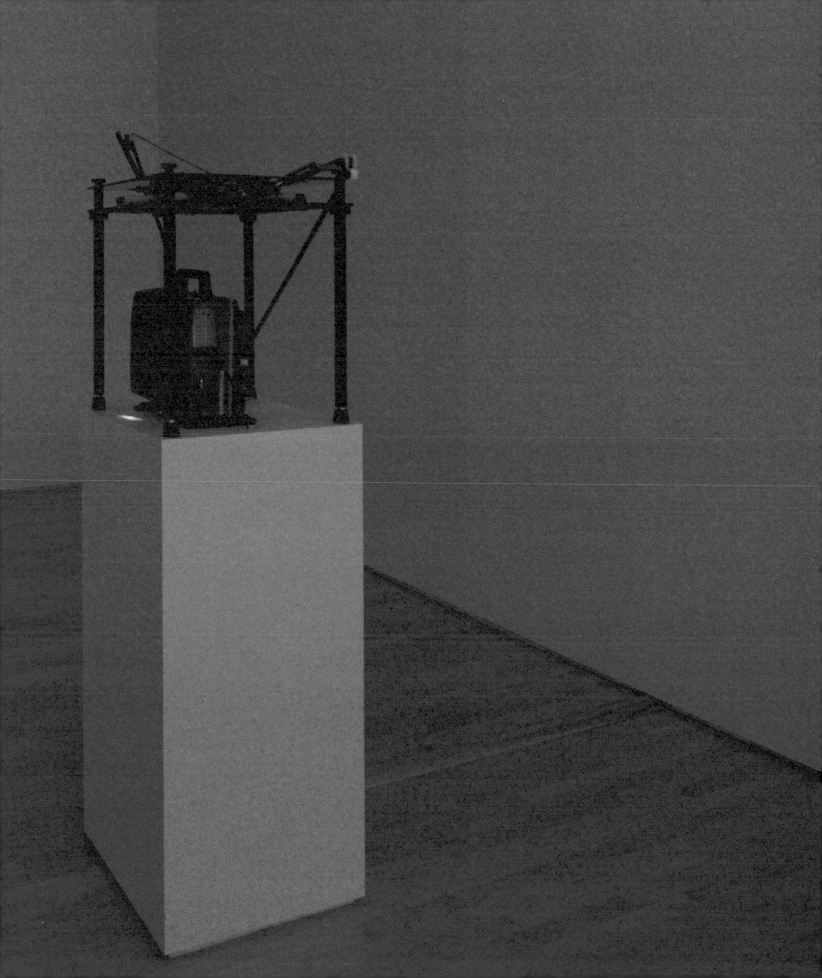

MURDER ON THE ROOF

from THE HISTORY OF PHOTOGRAPHY REMIX

Transparency in light box, 30 x 20 inches, 2005

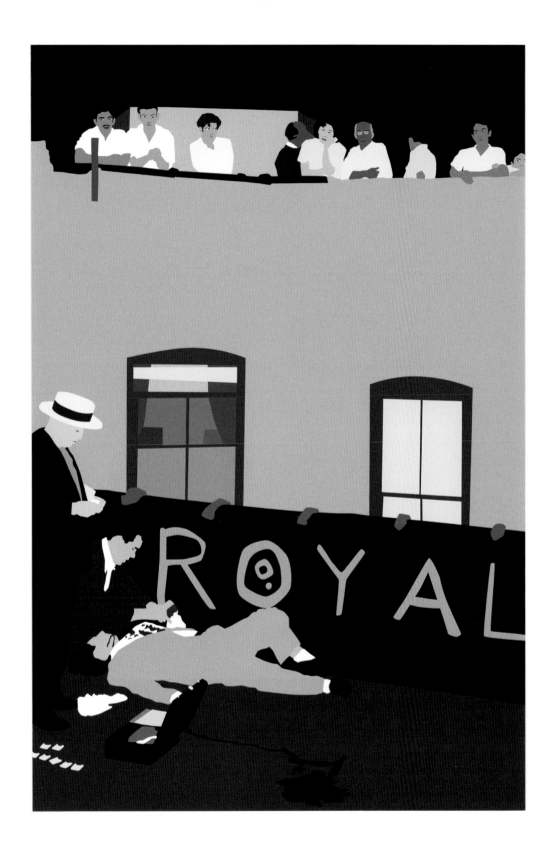

THIRTEEN MOST WANTED MEN

Digital drawing, 2017

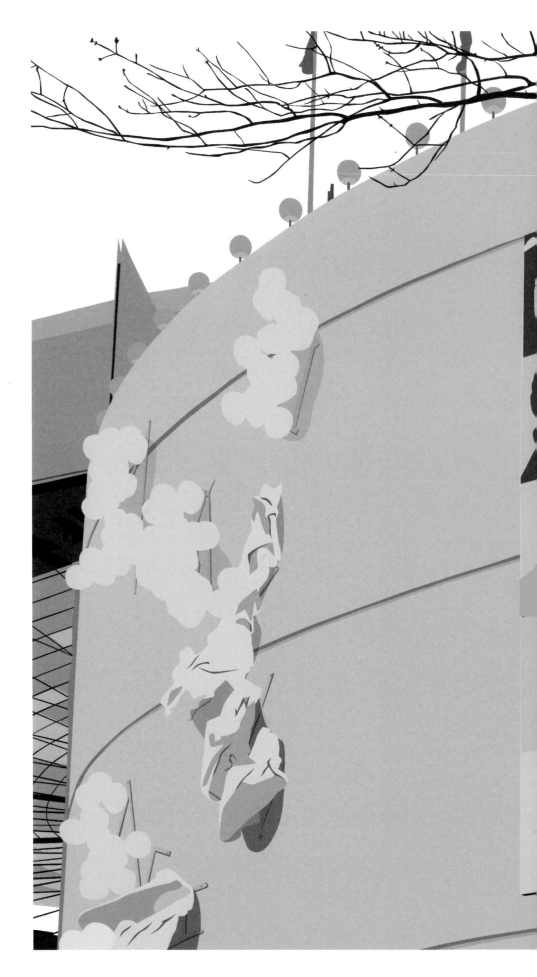

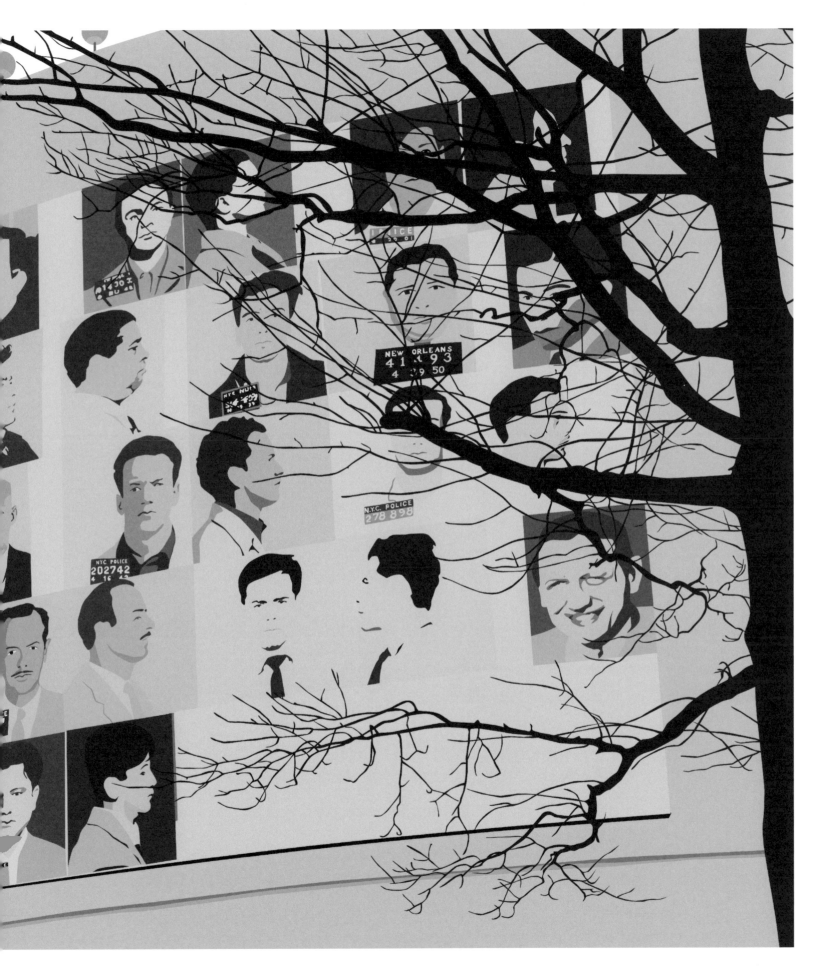

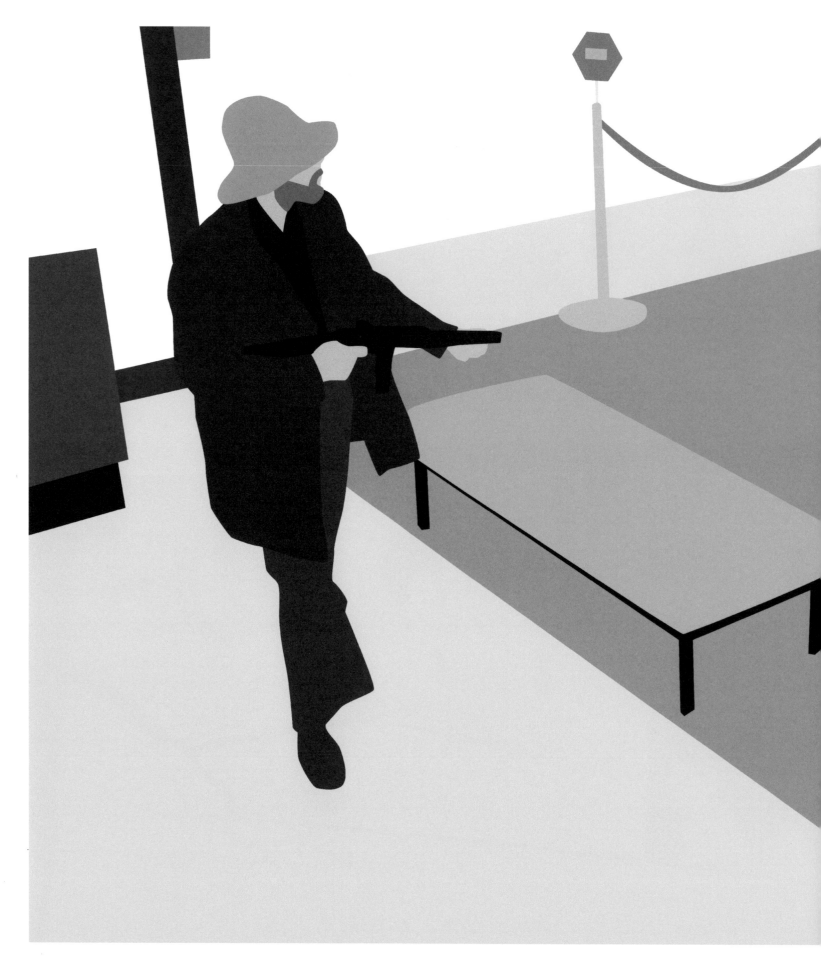

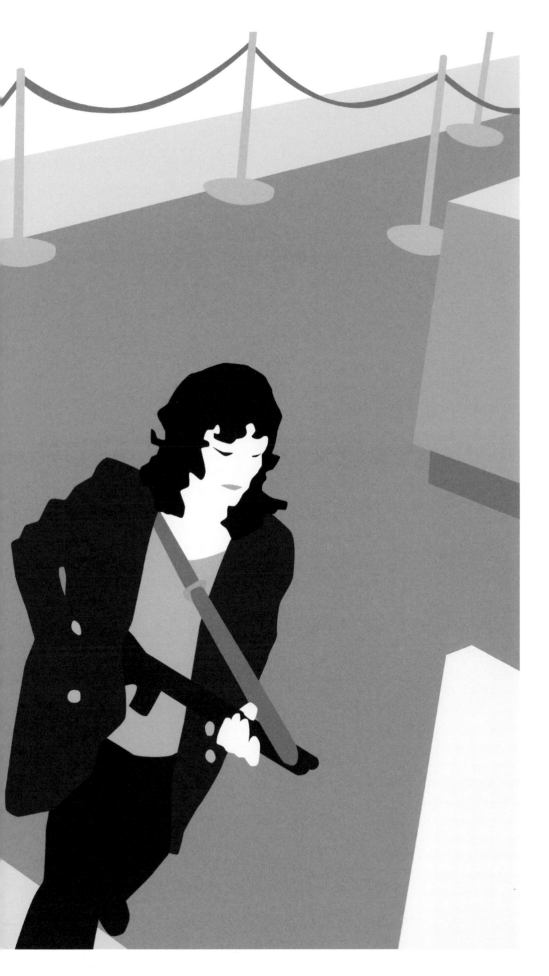

HIBERNIA BANK ROBBERY
from
THE HISTORY OF PHOTOGRAPHY REMIX

Transparency in light box, 24 x 36 inches, 2005

FOLLOWING SPREAD:

THE HISTORY OF PHOTOGRAPHY REMIX

35mm slide projection, 2004-2006

Installation view
Minneapolis Institute of Art, 2010
Photograph by Amanda Hankerson
Courtesy Minneapolis Institute of Art

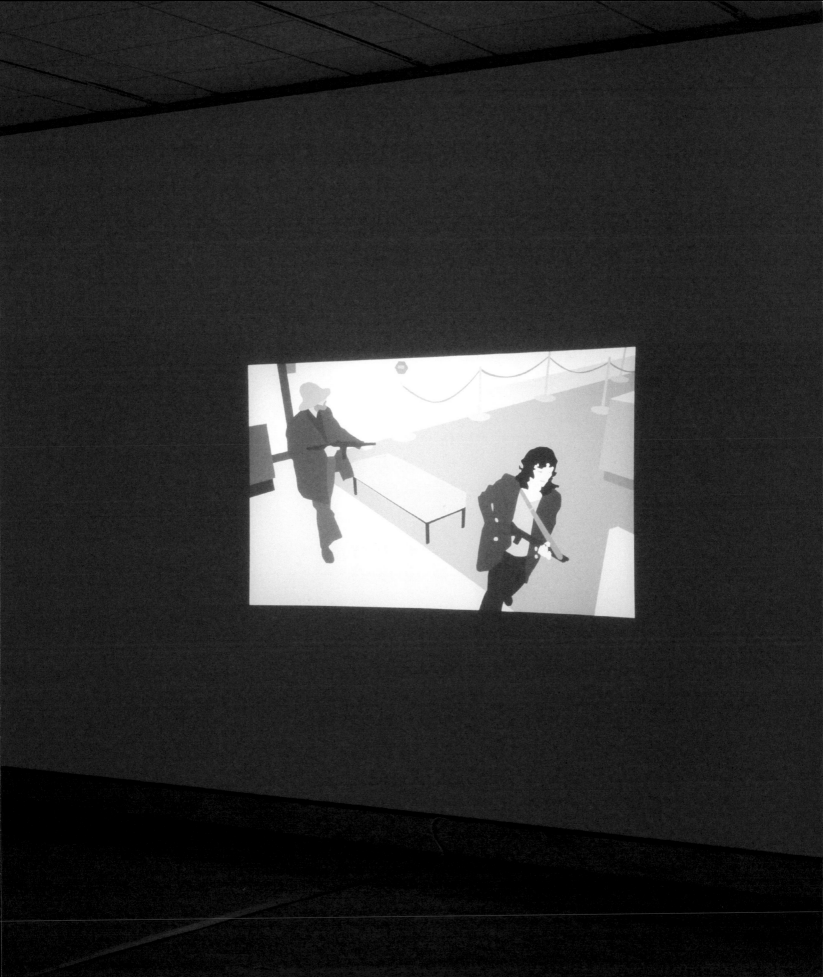

DEATH IN GENEVA

Transparency in light box, 21 x 28 inches, 2017

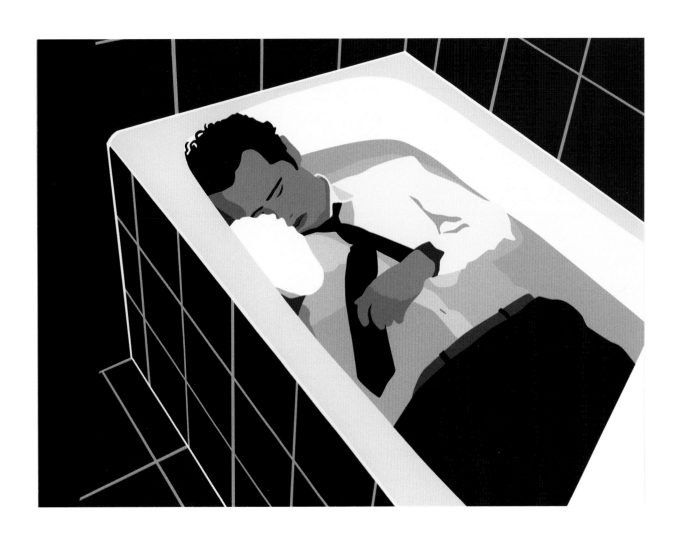

THE SIMPSON VERDICT

Video (color, sound), 2 min. 50 sec., 2002

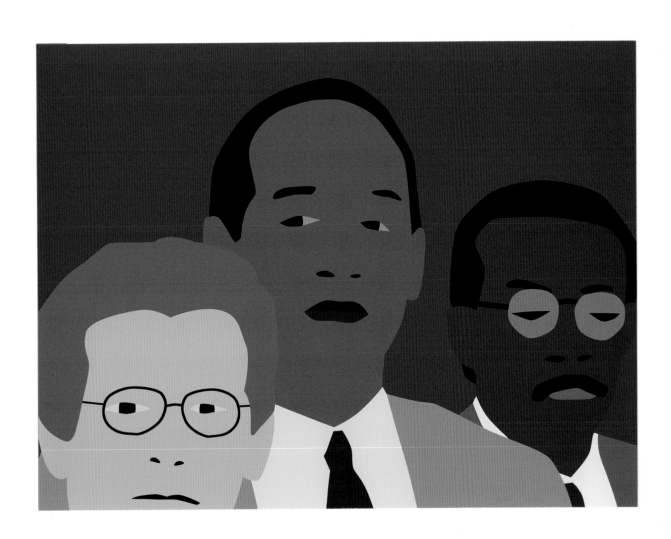

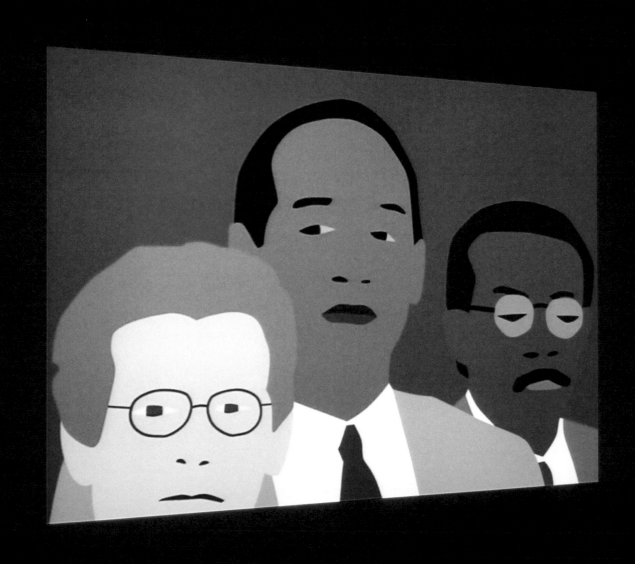

THE SIMPSON VERDICT

Video (color, sound), 2 min. 50 sec., 2002

Installation view
Pier 24 Photography, San Francisco, 2011
Photograph by Tom O'Connor
Courtesy Pier 24 Photography, San Francisco

CHAPTER 2: Gardner Museum Revisited

CRIME SCENE

Transparency in light box, 24 x 34 inches, 2016

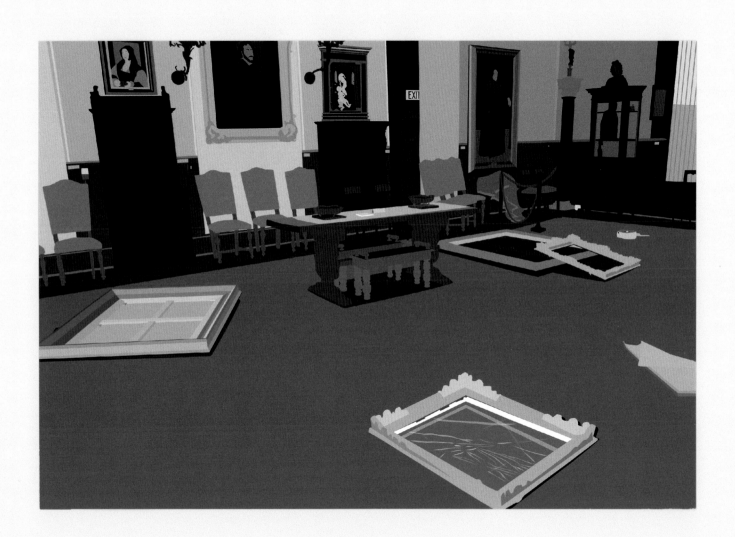

EMPTY FRAME

Transparency in light box, 24 x 33 inches, 2015

FOLLOWING SPREAD:

GARDNER MUSEUM REVISITED

Installation view
Christopher Grimes Gallery
Santa Monica, California, 2016
Courtesy Christopher Grimes Gallery, Santa Monica

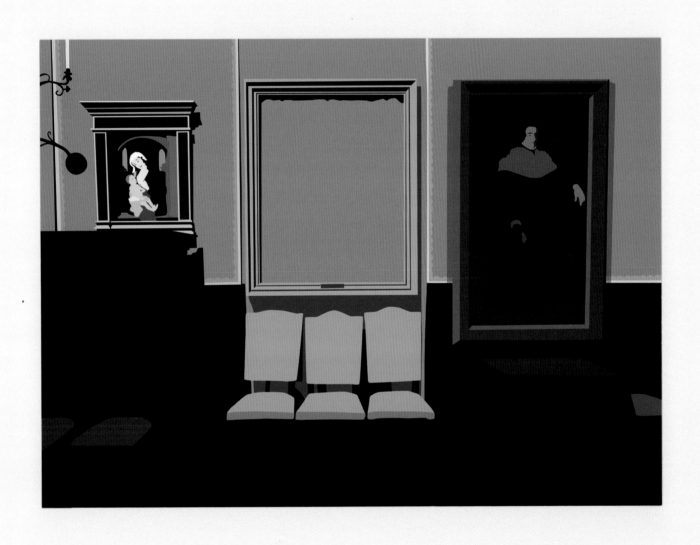

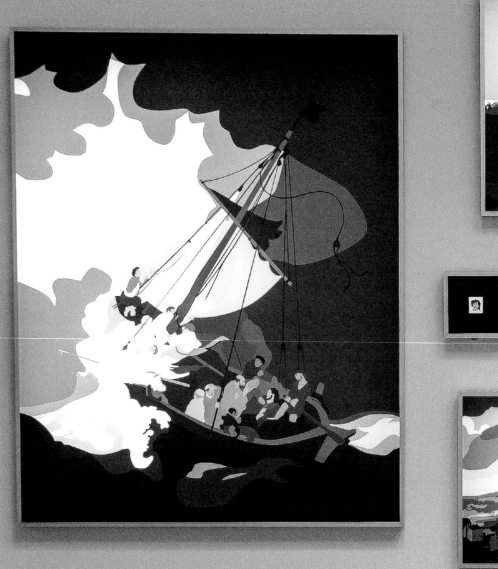
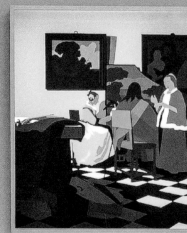

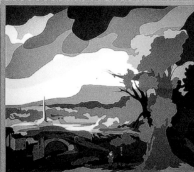

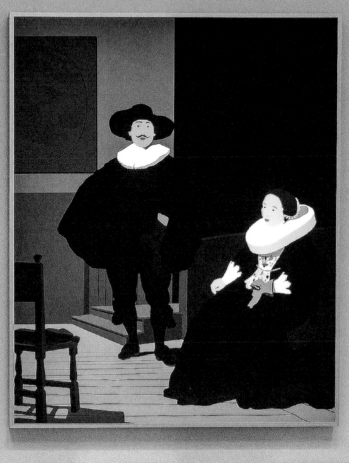

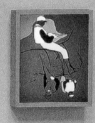
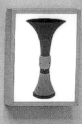

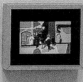

PORTRAIT OF THE ARTIST AS A YOUNG MAN

Transparency in light box
2 x 2 inches (image size)
8 x 8 inches (transparency size), 2015

THE STORM ON THE SEA OF GALILEE

Transparency in light box, 62 x 50 inches, 2015

FOLLOWING SPREAD:

ROTHERWAS PROJECT NO. 2: KOTA EZAWA, *GARDNER MUSEUM REVISITED*

Installation view
Mead Art Museum, Amherst College, 2017
Photograph by Maria Stenzel
Courtesy Mead Art Museum

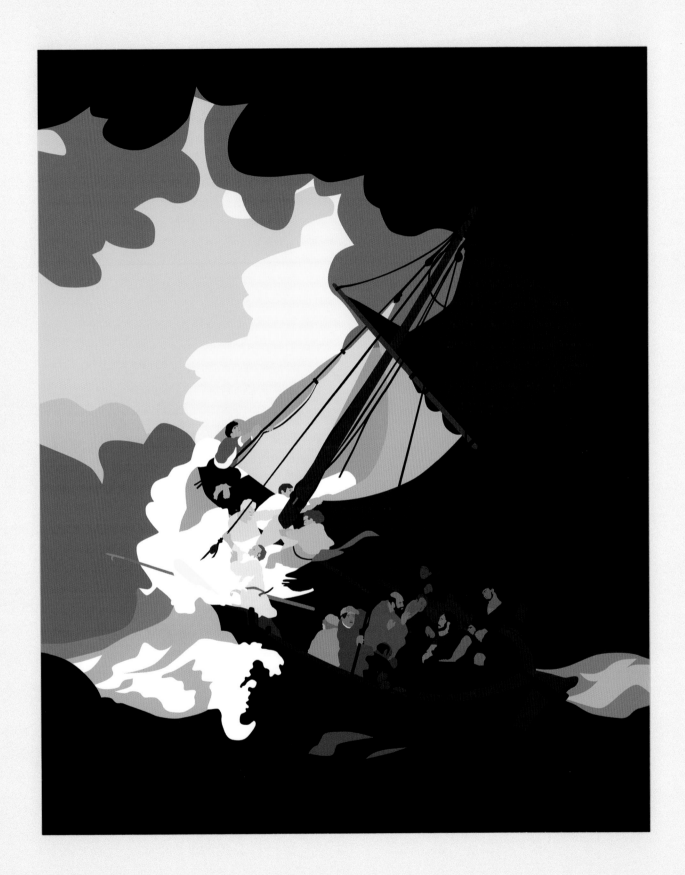

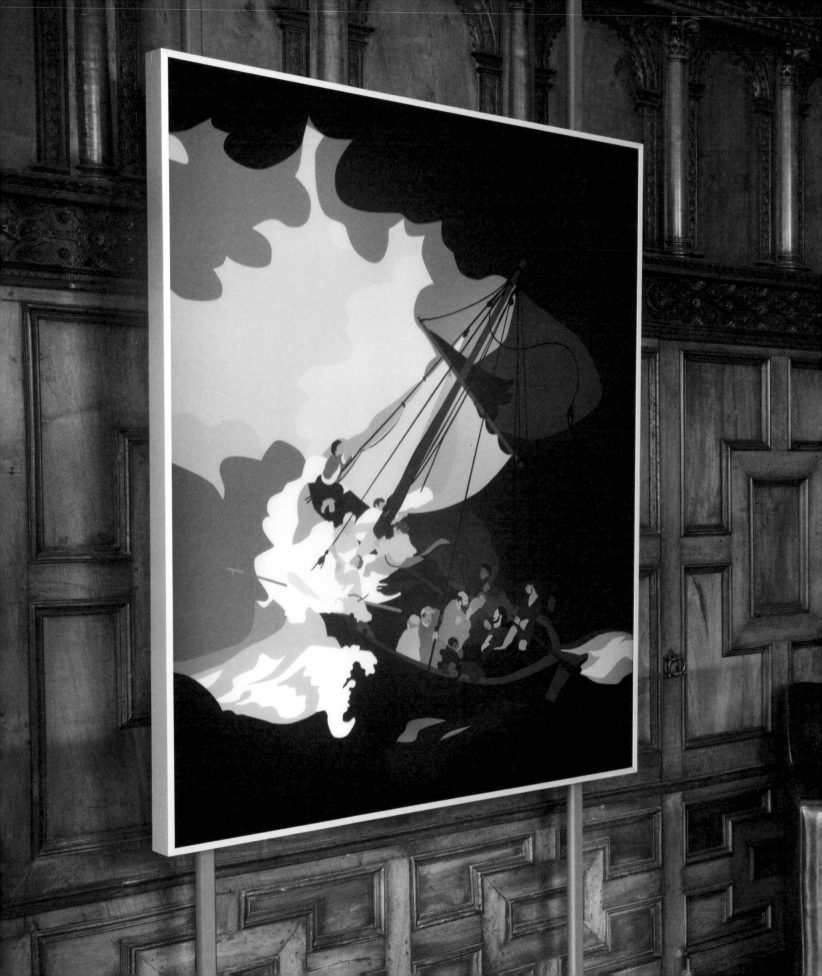

FINIAL

Transparency in light box, 17 x 12 inches, 2015

FOLLOWING PAGE 44:

LA SORTIE DU PESAGE

Transparency in light box, 8 x 13 inches, 2015

FOLLOWING PAGE 45:

PROCESSION ON A ROAD NEAR FLORENCE

Transparency in light box, 8 x 10 inches, 2015

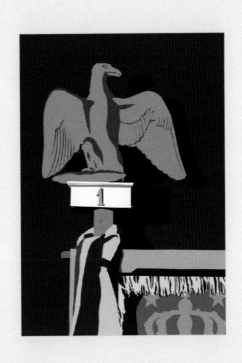

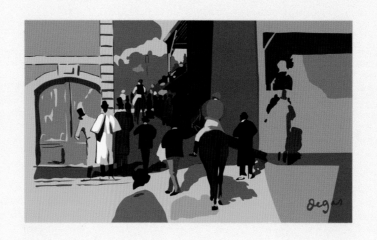

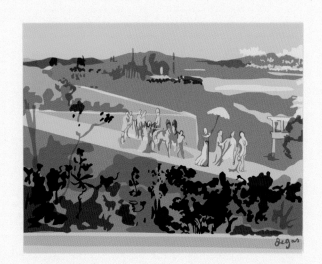

THE CONCERT

Transparency in light box, 28 x 25 inches, 2015

FOLLOWING SPREAD:

ROTHERWAS PROJECT NO. 2: KOTA EZAWA, *GARDNER MUSEUM REVISITED*

Installation view
Mead Art Museum, Amherst College, 2017
Photograph by Maria Stenzel
Courtesy Mead Art Museum

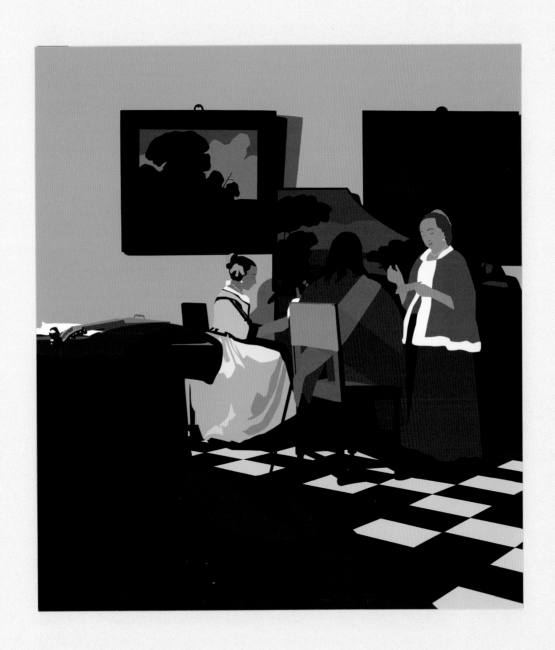

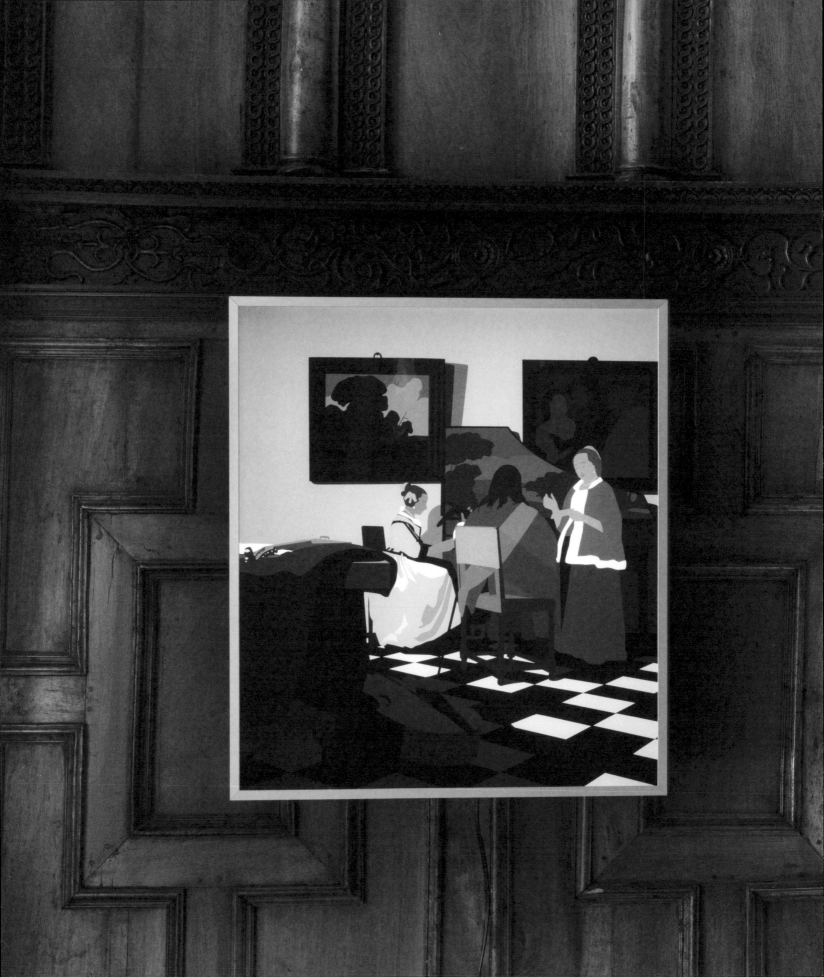

THREE MOUNTED JOCKEYS

Transparency in light box, 12 x 10 inches, 2015

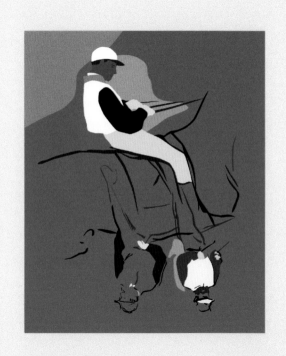

A LADY AND GENTLEMAN IN BLACK

Transparency in light box, 52 x 43 inches, 2015

FOLLOWING PAGE 54:

PROGRAM FOR AN ARTISTIC SOIREE II

Transparency in light box, 10 x 13 inches, 2015

FOLLOWING PAGE 55:

PROGRAM FOR AN ARTISTIC SOIREE I

Transparency in light box, 10 x 15 inches, 2015

FOLLOWING SPREAD PAGES 56–57:

ROTHERWAS PROJECT NO. 2: KOTA EZAWA, *GARDNER MUSEUM REVISITED*

Installation view
Mead Art Museum
Amherst College, 2017
Photograph by Maria Stenzel
Courtesy Mead Art Museum

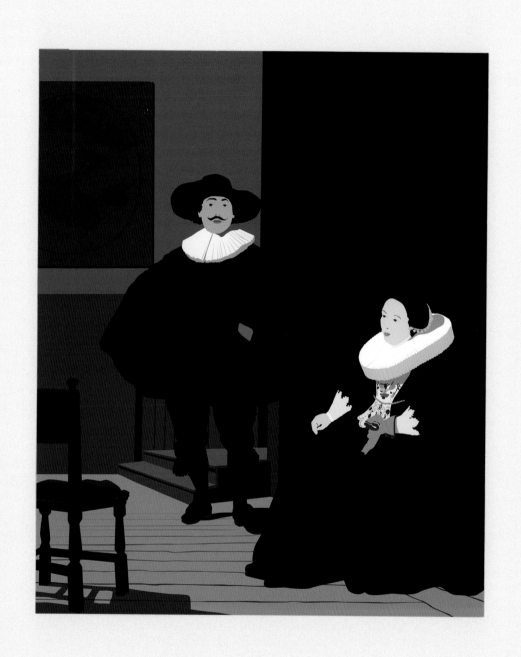

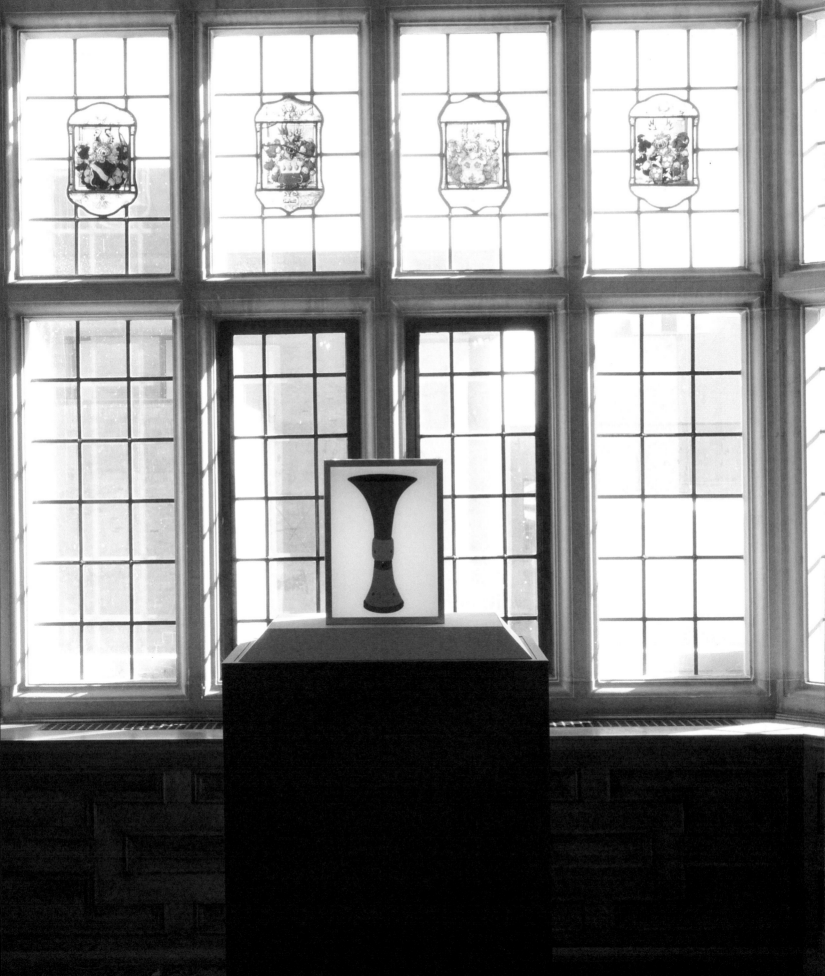

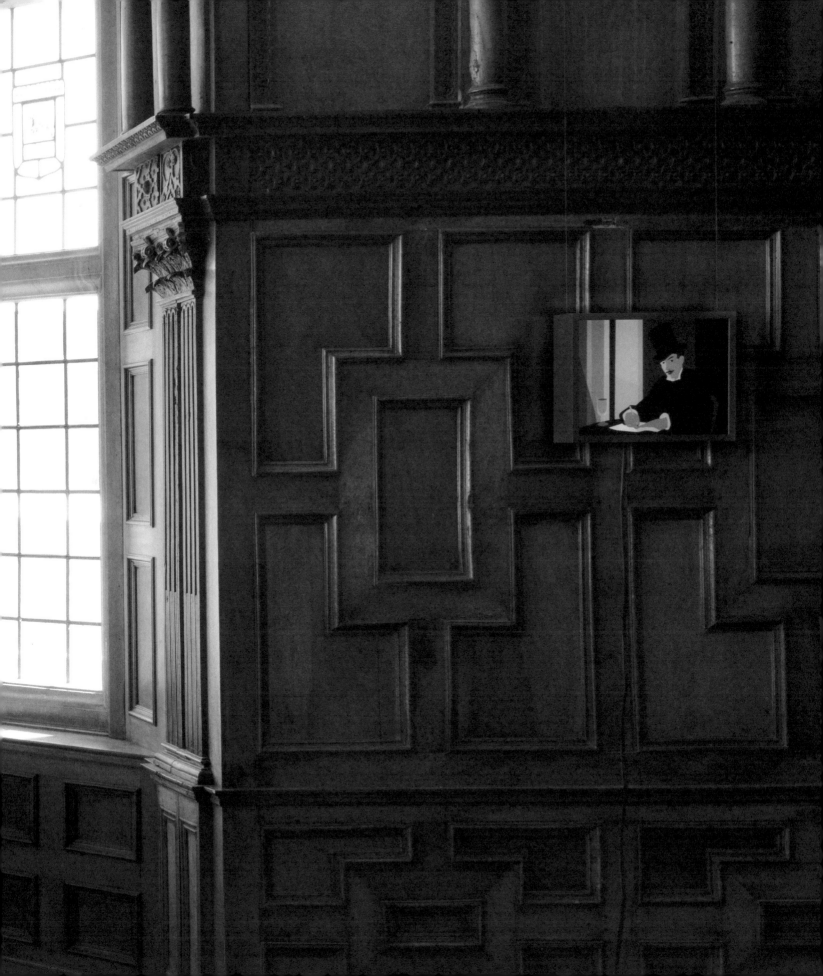

CHEZ TORTONI

Transparency in light box, 10 x 13 inches, 2015

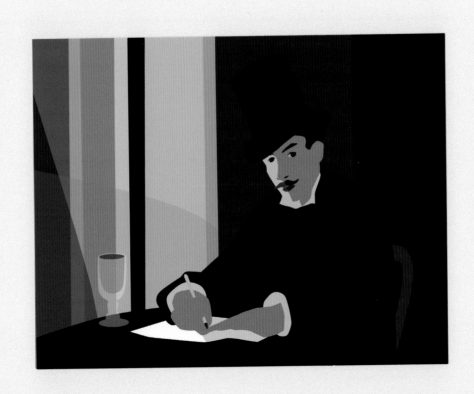

GU

Transparency in light box, 12 x 9 inches, 2015

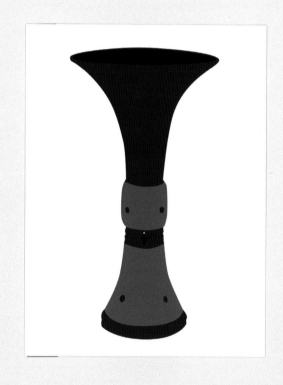

LANDSCAPE WITH AN OBELISK

Transparency in light box, 22 x 28 inches, 2015

FOLLOWING SPREAD:

DOUBLE TAPE

Two-channel video (black and white, silent), 5 min. 45 sec., 2015

Installation view
Christopher Grimes Gallery, Santa Monica, California, 2016
Courtesy Christopher Grimes Gallery, Santa Monica

FOLLOWING PAGES 66–67:

DOUBLE TAPE, 2017

Two-channel video (black and white, silent), 5 min. 45 sec., 2015

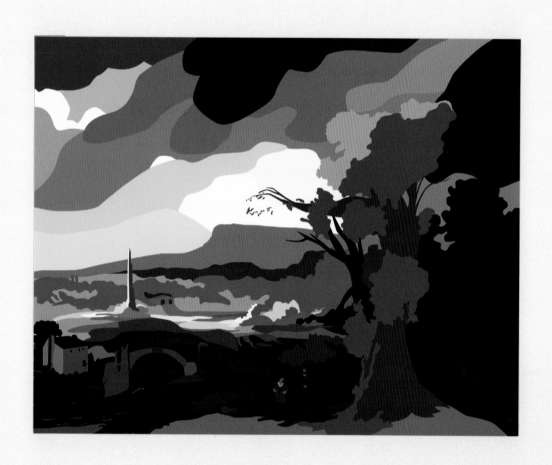

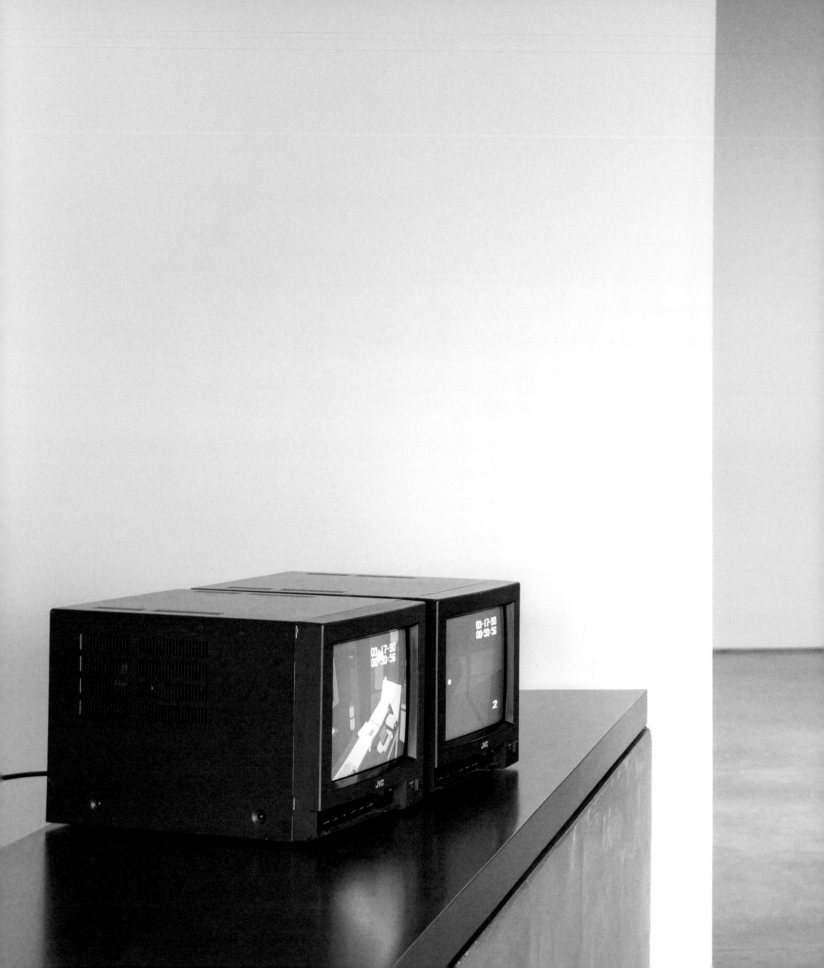

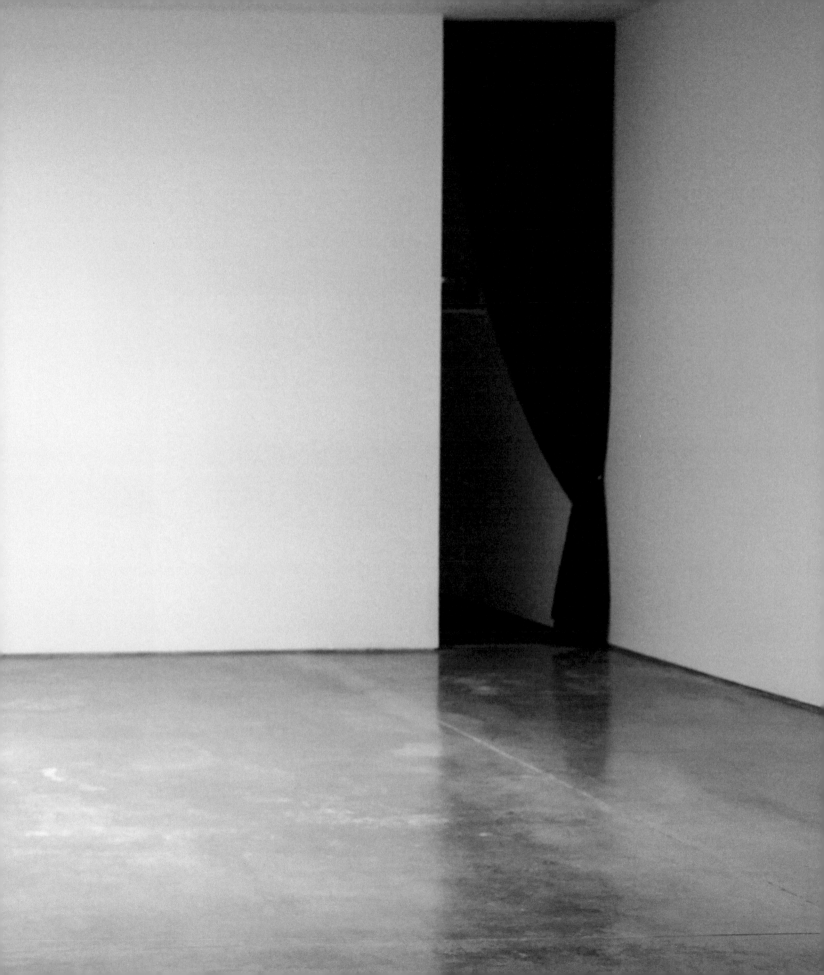

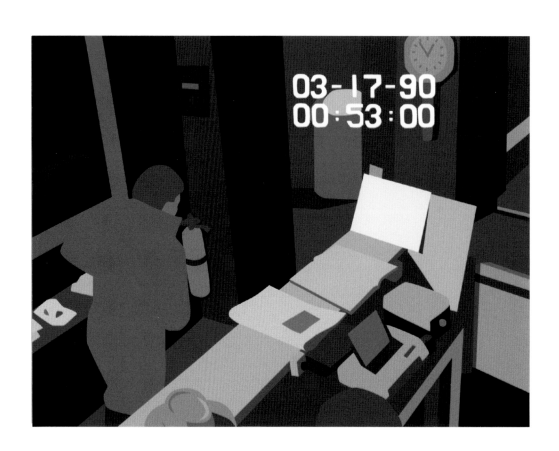

CHAPTER 3: That Obscure Object of Desire

ADELE BLOCH-BAUER I

Transparency in light box, 54 x 54 inches, 2016

FOLLOWING SPREAD:

ADELE BLOCH-BAUER I

Installation view
Galerie Anita Beckers
Frankfurt a. M., 2016
Photograph by Frank Pichler

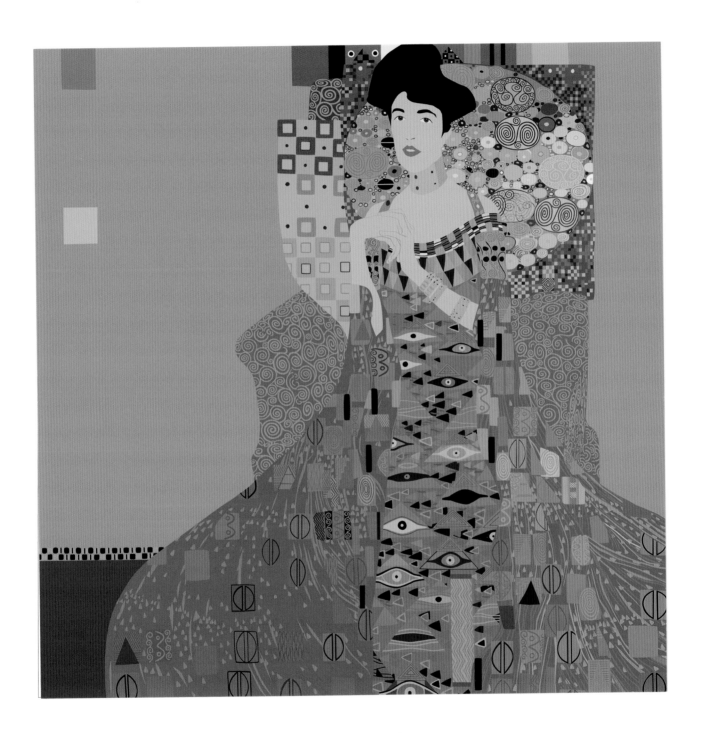

LA PASTORALE

Transparency in light box, 18 x 21 inches, 2017

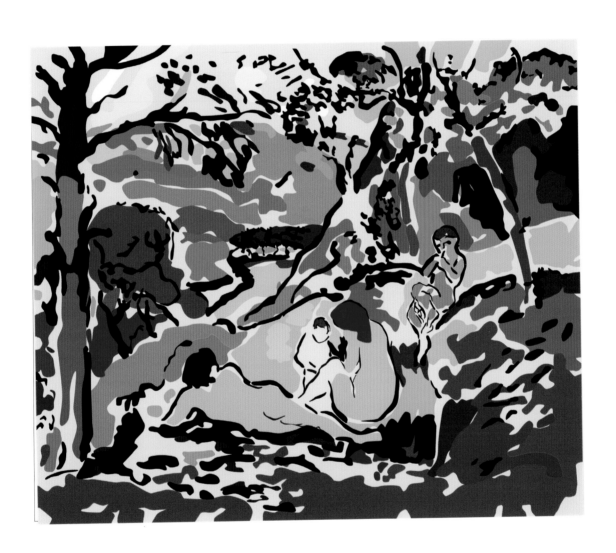

EMPTY FRAMES

Digital drawing, 2017

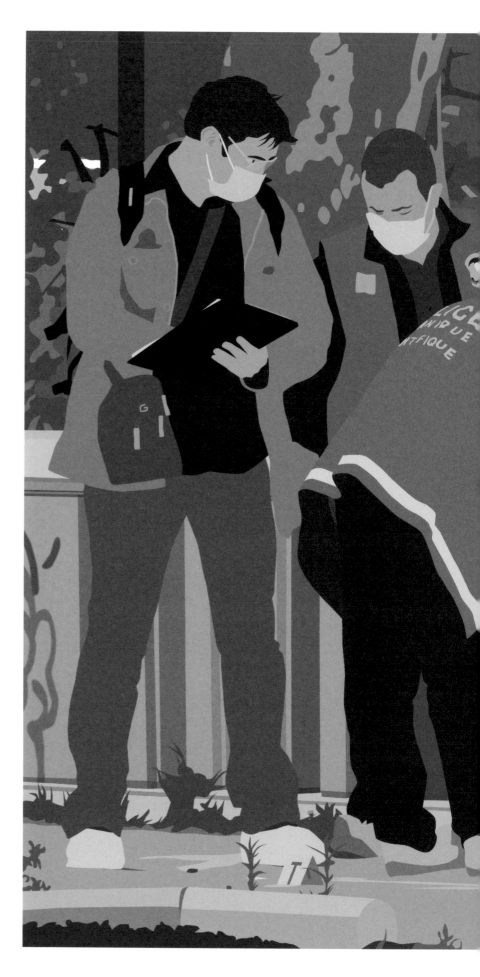

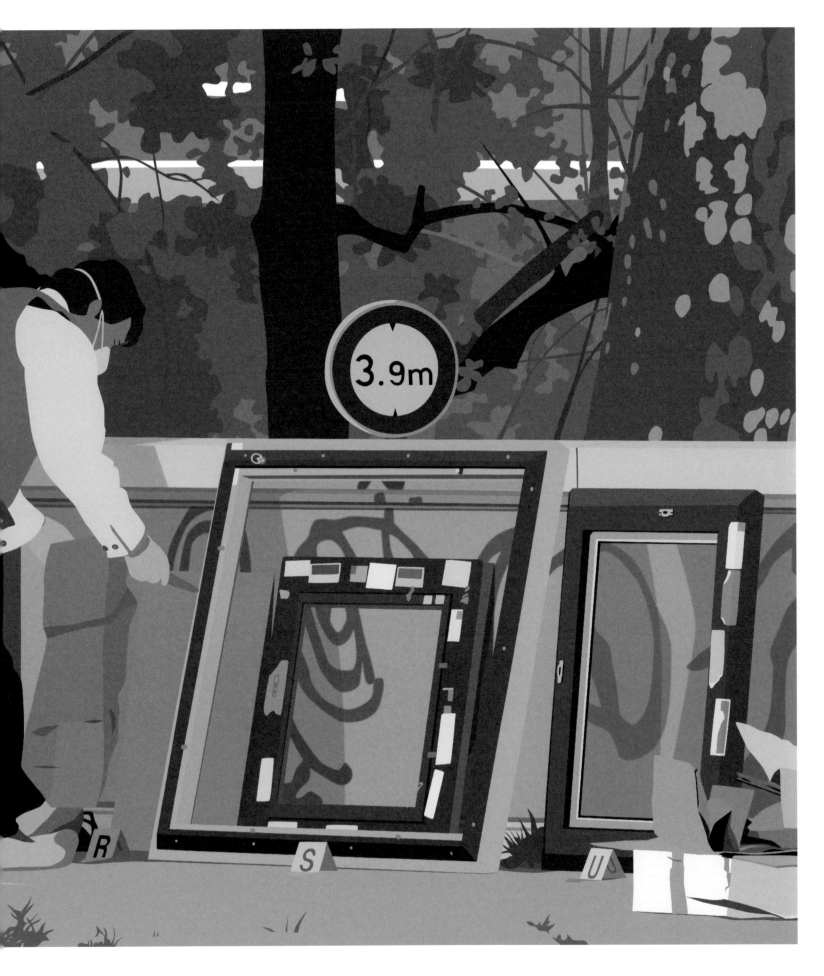

THE SCREAM

Transparency in light box, 33 x 26 inches, 2016

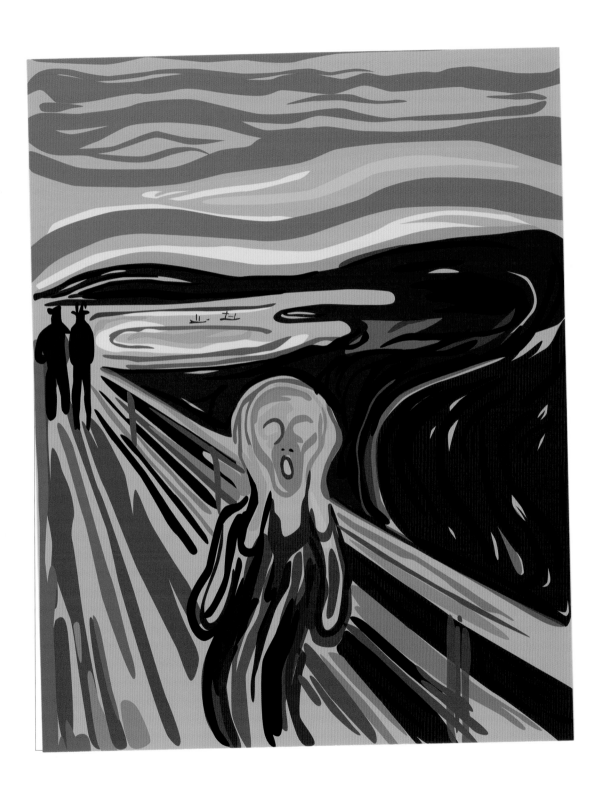

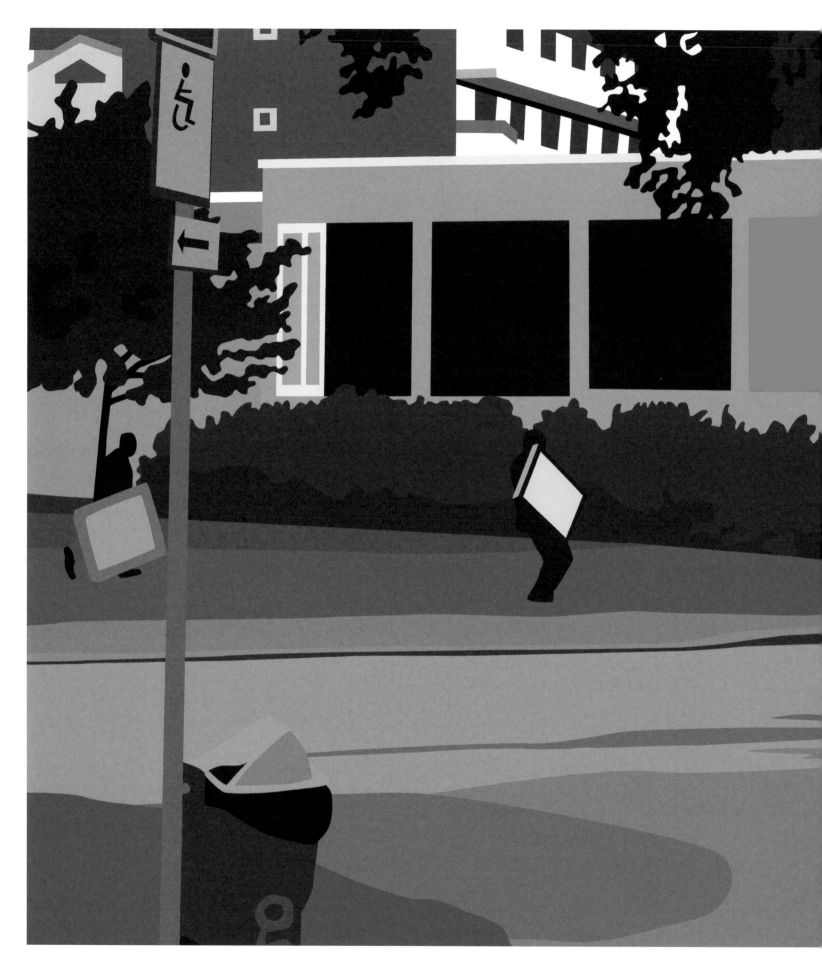

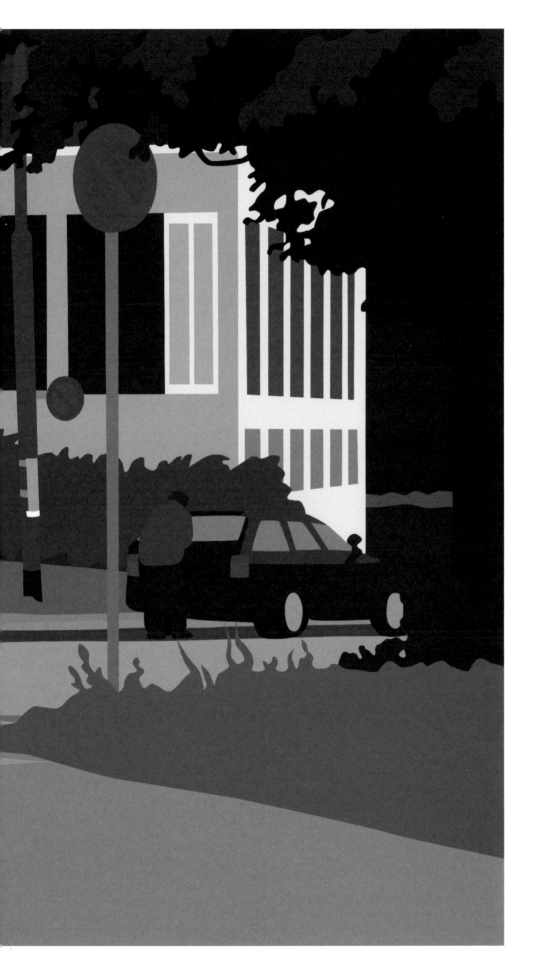

MUNCH THEFT

Digital drawing, 2017

CHAPTER 4: Writing Is a Form of Drawing

THE SCENE OF THE [ART] CRIME Irene Hofmann

On March 10, 1914, Canadian suffragist Mary Richardson walked into London's National Gallery and took a meat cleaver to Diego Velázquez's 1651 masterpiece, *The Toilet of Venus*.

Her attack caused the painting's protective glass to shatter and left seven slashes in the canvas, causing significant damage to the area between the shoulders of Venus's reclining nude form. Richardson claimed her action was provoked by the arrest of a fellow suffragette the day prior. Richardson was arrested, held without bail, tried, and sentenced to six months in prison—this was the maximum allowed at the time for the destruction of an artwork. The painting was later successfully repaired by the National Gallery's conservation staff and returned to display. *The Toilet of Venus*, also known as *The Rokeby Venus*, is now one of the most famous and popular works in the National Gallery's collection.

In 1941 Gustav Klimt's radiant gold-flecked portrait of Adele Bloch-Bauer was looted by the Nazis from the Bloch-Bauer's Vienna town house. It was one of five Klimt paintings taken from the residence and one of the artist's most iconic works. The illegally seized paintings were housed in Vienna's Belvedere Gallery where they would remain in the possession of the Austrian government for over sixty years. In 1996 the Austrian government passed a restitution law allowing for property stolen by the Nazis to be returned to its rightful owners. This ruling prompted Adele's niece, Maria Altmann, to begin a legal battle with the Austrian government to regain possession of her family's Klimts.

Following eight years of litigation by Altman, in 2006, the paintings were finally returned to the family. Portrait of *Adele Block-Bauer I* (1907) also known as *The Woman in Gold*, was subsequently sold at auction and now hangs in the Neue Galerie in New York. The history of *The Woman in Gold* is one of the most storied cases of Nazi era theft and repatriation.

While *The Woman in Gold* was returned to its original owners, today there are an estimated 100,000 works of art still unaccounted for from the Nazi occupation.

On March 18, 1990, two men posing as Boston police officers arrived at the Isabella Stewart Gardner Museum—it was early in the morning and the only people in the museum were a few security guards. Claiming they were responding to a disturbance, they conned their way past the Gardner's security personnel. Once in the museum, the men took the guards into the basement, handcuffed them, and proceeded to steal thirteen works of art. Over the course of just one hour, they moved throughout the museum and stole works valued in excess of $500 million — this was the largest-value theft of private property in history. Despite efforts by the FBI and multiple probes around the world, no arrests have been made and no works have been recovered. Today, the theft remains unsolved and on the FBI's list of the top ten art crimes.

Among the stolen Gardner works were three Rembrandts including a self-portrait from 1634, *A Lady and Gentleman in Black* (1633), and his only known seascape *Christ in the Storm on the Sea of Galilee* (1633). Also among the missing were Édouard Manet's *Chez Tortoni* (1878–80), five works on paper by Edgar Degas, and *The Concert* (1658–60), one of only thirty-four known works by Vermeer and thought to be the most valuable unrecovered painting at over $200 million.

These stolen works were originally purchased by the visionary art collector Isabella Stewart Gardner (1840–1924) and intended to be left on permanent display in the museum that bears her name. Since the collection and its layout are permanent, following the theft, bare spaces on the walls and empty frames (from which larger canvases were cut by the thieves) remain in homage to the missing works and as hopeful placeholders awaiting their future return.

Shortly after the heist, the Gardner Museum offered a reward of $5 million for information leading to the recovery of these works. In May 2017, the Gardner increased this reward to $10 million, signaling the resolve of the museum and the authorities and the ongoing efforts of the investigation.

———

One hundred years after the vandalism of *The Toilet of Venus*, seventy-five years after the looting of *The Woman in Gold*, and twenty-five

years after the Gardner Museum heist, artist Kota Ezawa has revisited each of these crimes and the legacy of the images that were aggrieved.

Rendering each of these artworks anew through digital means in a style that reduces each to its essential elements, Ezawa creates works that serve as reminders of criminal evidence and stand-ins for famous originals.

Presented to scale and as glowing light box transparencies, Ezawa's abstracted images appear as essential expressions of some of art history's most treasured and enduring pictures. While Ezawa's animation-style renderings are clearly not replicas, they do however provide just enough information to allow our own visual memory to step in and provide further details of these famed and oft-reproduced works.

While Velázquez's *The Toilet of Venus* has been repaired and Klimt's *The Woman in Gold* has been returned, the Gardner Museum's thirteen works remain lost. In the hands of Kota Ezawa they return to us as glowing apparitions of the past rendered through technologies of the present. Although we may not see the return of the Gardner Museum works for another generation or two, in the meantime, we have Kota Ezawa's *Gardner Museum Revisited* (2016), where some of the great figures of art history are arranged in a forensic lineup allowing us to pay homage to their original referents and to hope for their safe return.

GHOSTS Niko Vicario

Picture the thousands upon thousands of social media selfies generated by Anish Kapoor's sculpture *Cloud Gate* (2004) in Chicago's Millennium Park. On the other end of the spectrum, you may not picture Tino Sehgal's *Kiss* (2003), as the artist prohibits you from photographing this "constructed situation," seeking to shield firsthand experience from an army of circulating image files. Around the same time as these works were conceived, Thomas Ruff took JPEGS from the Internet, enlarged them so as to expose their pixelated armature, exhibiting and selling them as large-scale prints. Since then, practices dubbed "post-Internet art" have investigated the impact of technological change, not least the relation between life and our various screens.

But before all of this, indeed before the Internet was the cultural force it is now, one of those anachronistic storehouses of image-originals—museums—was pillaged. In March 1990, thirteen objects were stolen from the Isabella Stewart Gardner Museum in Boston. These were not just any old things but included paintings by the likes of Rembrandt, Vermeer, Manet, and Degas.

While the museum may be an ersatz palazzo, inside one nevertheless finds *the real thing*. Although the works of art housed in the museum had been produced abroad, Gardner had nevertheless been insistent, once they entered the collection, that they *not be moved*. Accordingly, since the robbery, the museum dramatically displays empty frames where the stolen paintings once hung.

At the time of the heist, Kota Ezawa was studying art in Düsseldorf, before moving to San Francisco in 1994. It was in 2001 that Ezawa began experimenting with digital animation. In works such as *The Simpson Verdict* (2002) and *Who's Afraid of Black, White and Grey* (2003), Ezawa translated found footage from television news and cinema into a reduced vocabulary of forms via a process of rotoscoping with vector drawings composed on a computer. Lines are discarded in favor of blocks of color; expression is brought to the edge of affect. With *The History of Photography Remix* (2004–2006), a slide show, Ezawa's recently minted signature style was now directed toward iconic photographs by the likes of William Henry Fox Talbot and Nan Goldin.[1]

1. For insightful discussions of these and other works by Ezawa, see Matthew Higgs, "Kota Ezawa," *Artforum* (February, 2005), 162–3 and Kota Ezawa in conversation with Karen Beckman, "Animation, Abstraction, Sampling," *Grey Room* 47 (Spring 2012), 98–109.

The remix, the sample, cut-and-paste, the mash-up, the meme: these terms entered the zeitgeist, swapping and blurring metaphors. The role of DJ seemed to suit Ezawa at a historical moment when critic/curator Nicolas Bourriaud had begun to frame a variety of artistic practices through the lens of "postproduction."[2] If an earlier generation of artists associated with appropriation, such as Richard Prince and Sherrie Levine, had found themselves entangled in intellectual property rights disputes, Ezawa's process handily circumnavigated such allegations by unequivocally transforming the referent.

Trawling the FBI's database of stolen art in 2015, Ezawa came across the stolen Gardner works, whereabouts still unknown. An art heist presented Ezawa with a particular circumstance—when the original that provided the basis for a multitude of copies suddenly became erased from public visibility. Evidence of its existence (past and present) is now secured only by its reproductions. The estimated value of the stolen works—$500 million—tells us much about the esteem afforded to originals, while Ezawa's practice, on the other hand, tells us much about the mutability and shareability of images.

Nevertheless, in the suite of works that use the Gardner robbery as their raw material, a Rembrandt and a Vermeer become irrefutable Ezawas; authorship survives. Beyond stylistic transformations, paintings become photographs become drawings become light boxes in a sequence of successive remediations.[3]

The glowing format of the light boxes produces a haunting presence. Writing in the *Los Angeles Times*, Sharon Mizota referred to Ezawa's Gardner series as "ghost works."[4] Indeed, specific light boxes stand in for specific stolen works of art and thus serve as phantasmal effigies. Notably, ghostliness also characterized Walter Benjamin's notion of "aura," the spectral emanation he attributed to works of art, an aura he claimed was diminished by mechanical reproduction.[5] What's more, we might consider the eerie space of the dimmed art history classroom where copies—from lantern slides to JPEGS—have been instrumentalized by a field paradoxically dedicated to fetishizing the singular, authenticated original.

But the ghost also pervades more recent techno-cultural developments. "Ghost imaging"

2. Nicolas Bourriaud, *Postproduction: Culture as Screenplay: How Art Reprograms the World* (New York: Lukas & Sternberg, 2002).

3. See J. David Bolter, *Remediation: Understanding New Media* (Cambridge, MA: MIT Press, 2000).

refers to the replication of a computer's hard disk, converted into a single compressed file. *Ghosting* (with its verb form *to ghost* added to the *Merriam-Webster Dictionary* in 2017) can denote a person's disappearance from a physical location, from an intimate relationship or from online communication. In tandem with this logic, a ghost icon serves as the logo for the Snapchat app through which a variety of texts, images, and videos can be sent from smartphone to smartphone before self-deleting. Presence, visibility, compression, storage, disappearance, and erasure are all mutually embedded.

Ezawa's light boxes emanate a mechanized aura not so different from that luminescence produced by computers and smartphones. But in contradistinction to the swarm of copies available on those devices, Ezawa produces a single surrogate for each stolen work. While he may use a computer for his vector drawings, Ezawa is nevertheless engaged in a practice that requires both labor and precision; the process thus confounds the equation of digitization with de-skilling. Complicating things further, the printing and ensconcing of the image in the form of a light box requires collaboration with an analog photography lab. This hybrid of digital and analog thus suggests an anachronism, anachronism also characterizing the relationship between the diverse eras in which the stolen works of art were made and their updating by Ezawa.

Can a Rembrandt painting be ghosted? Does a self-deleting selfie ever truly disappear or does it come back to haunt us? To whom does an image belong? Are we in a historical moment that will be remembered for its "lossy compression," a transfer process characterized by the shedding of data in favor of streamlined transmission, or for the total eclipse of the crusty canvas by its digital double? What Ezawa's work gives us is the glow produced by the afterlives of images. There is no going back.

4. Sharon Mizota, "The scenes of a crime: Kota Ezawa revisits the Gardner Museum theft," *Los Angeles Times*, March 1, 2016.

5. Walter Benjamin, "The Work of Art in the Age of Mechanical Reproduction" [1935] in *Illuminations* (New York: Schocken Books, 1969), 217–251.

CELLMATES Jordan Kantor

For several years in the mid-2000s, Kota Ezawa and I shared a studio in the Dogpatch neighborhood of San Francisco. The space was dreamy: more a throwback to the raw downtown lofts of 1960s New York than something one could reasonably imagine to find in the present day, especially now that the area has become a favorite of start-up companies. Our studio was divided into two sections by a partition wall, but the blue door between our work zones was almost always ajar, registering the openness and exchange between our practices then. Neither of us works there any longer, but, reflecting back, I realize that the best thing about that studio wasn't so much its soaring ceilings or wall of windows, as the professional intimacy it afforded. Kota and I saw each other almost daily. It was through the hours working quietly side by side, as well as casual conversation during our frequent lunches together, that I came to understand better some of his fundamental habits of making and to see his work in a new light.

I remember during one of our conversations, Kota mentioned the primacy of formal concerns in his work. The comment surprised me a little and lingered in my mind. Despite the many compelling referents in his films, light boxes, and prints, Kota was underscoring his interest in how an image

functions on its own—as an abstraction, even. In an oeuvre that includes figures from popular culture, politics, art history, sports, and beyond, his emphasis on form (as opposed to these subjects) may seem counter intuitive. However, from what I know of his studio activity—which consists primarily of long stretches sitting before a computer screen, digital stylus in hand—his comment makes perfect sense. For him, deciding what image to work on is only the starting point. And while this choice may involve months of conscious (and doubtless unconscious) mulling, most of his studio time is spent in the work of translating a source image into an abstracted forest of digitized vectors. It is as if the source is almost a pretense to set into motion the regular practice of making form, a practice that is full of countless small-scale decisions, such as what the precise tonal difference should be between two gray planes of a building's facade, or how to render the transparent wash of a watercolor brushstroke with opaque, flattened digital shapes. While his final pieces can have a specific (and very contemporary) affectless tenor, this dissembles his working processes. Ultimately, Kota's work is an amalgam of lively, almost reflexlike, formal decisions made within the standards of his specific, and personal, aesthetic.

The felt tension between mute blankness and motivated energy is one of the things I most enjoy before Kota's work. His final objects are airtight in many ways, yet also strangely animate. I suspect this has to do with the manual beginnings of his process. For although Kota's hand is highly mediated by the matrix of his hardware (the computer), his software (various image processing programs), and his ultimate medium (various forms of digital and non-digital outputs), his work fundamentally passes through a hand. In this cooperation of hand and machine, Kota's practice evokes the concept of the uncanny in its most literal sense. By literally incorporating (as in bringing the body into) the desktop computer into his practice, Kota's work testifies to the ways in which technology and biology converge in our era. But the uncanny is also often an effect of Kota's work. His work can elicit feelings of shock and estrangement, such as those when one momentarily confuses animate and inanimate objects, like being taken aback by a mannequin caught out of the corner of the eye.

The particular ways in which time operates in Kota's work can heighten such uncanny feelings as well. If the present (and indeed perhaps our future) is integrated into Kota's working methods, how the recent past is experienced in real time remains at the forefront. As almost every text on his work explicates, historical references abound in Kota's work. I am most interested in how Kota's work reactivates the past via a heightened experience of time in the present. This functions most overtly in his moving image work, in which our durational experience of viewing is emphasized. I am always surprised how each time I view *The Simpson Verdict* (2002), I get chills on my scalp when the defendant is pronounced "not guilty." I think one reason this happens again and again has to do with the collapse of time between the event's literal historical occurrence and the moment of viewing in the present. (The slippage between the "real" audio and the "unreal" animated characters' responses may be another factor.) That is, this work calls attention to the idea that the act of remembering can only ever happen in the present, and this realization necessarily destabilizes the familiarized process of making sense of the world through coherent, linear narratives. While such a collapse of time and space seems an important aspect of all of Kota's work, it is especially germane in those pieces (such as those collected here in this book) that use artwork of the past to make artwork of the present.

~~The Night Watch~~ (2017) is a prime example of how Kota can collapse time zones to uncanny effect. This medium-sized light box recasts a documentary photograph of a man standing before Rembrandt van Rijn's *The Night Watch* (1642) immediately following an attack in which the iconic canvas

was slashed. Several distinct temporalities are depicted in the work, and they interact in different ways. Firstly, he has rendered the painting, which itself depicts Rembrandt's contemporaries. Here we see the seventeenth century, both in the figures depicted (Frans Banninck Cocq and his company) and in the artist depicting (Rembrandt). But ~~Night Watch~~ also clearly references 1975. This is the year in which the vandalism occurred, and the photograph that serves at the source for Kota's digital drawing was taken. By rendering the man in the suit, who clearly belongs to the 20th century, in the same abstracted visual language as the figures in the painting from a time hundreds of years prior, Kota destabilizes this temporal distance. The image's composition underscores this flattening: the photographed man and painted figures appear to face each other at equal, inverse angles in a new, shared "third space" of Kota's art. Yet another leap is evident here as well. By rendering the slashes in the painting in pure white (and omitting the shadows that give them dimension in the source photograph), Kota plays with the idea that they can be read as piercing his own work, the 2017 image before us. This strategy, humorously doubled by the fanciful visual joke that the spear of the painted soldier to the far right might have pierced the painting from *within* the image itself, emphasizes the "face" of his own light box in our own time and space (as viewers), and sets off a dizzying attempt to retrace our steps.

I don't have any specific claims to make for this kind of sophisticated visual play other than to profess that it is one of the experiences I seek in art. While Kota's work often deals with surrogates—indeed, the whole *Gardner Museum* project is predicted on the concept that Kota's drawings could stand in, even temporarily, for absent originals—so much of what his work does is emphasize the now time of looking. Kota's work resolutely puts itself before us, tempting us to ask questions, and prompting us to think about the dynamic interchange between past and present. How does the past create present experience and how, in turn, does the present write (and rewrite) the past? Kota's work prompts this line of inquiry in a general way, and reliably so; however, I am primarily concerned with the personal experience of looking that I have with it. And on this count, even though I know Kota is thousands of miles away as I write this, it weirdly feels as if we spent today in the Dogpatch together, and, for me, that feels like time well spent.

CHAPTER 5: V for Vandalism

THE THINKER

Transparency in light box, 26 x 20 inches, 2017

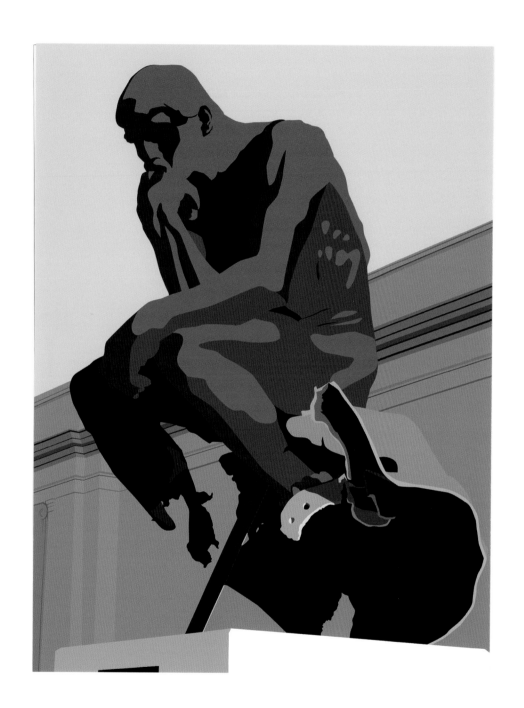

THE TOILET OF VENUS

Digital Drawing, 2017

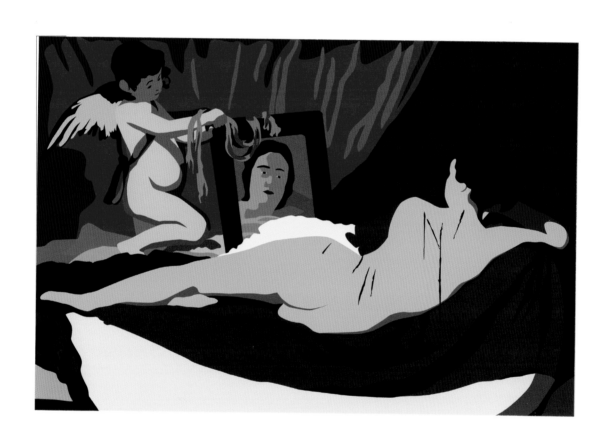

THE NIGHT WATCH

Transparency in light box, 28 x 20 inches, 2017

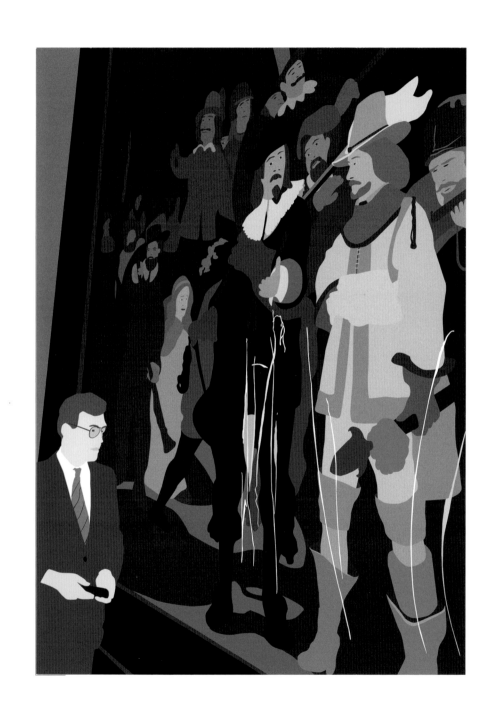

PORTRAIT OF ARCHDUKE ALBRECHT

Transparency in light box, 40 x 28 inches, 2016

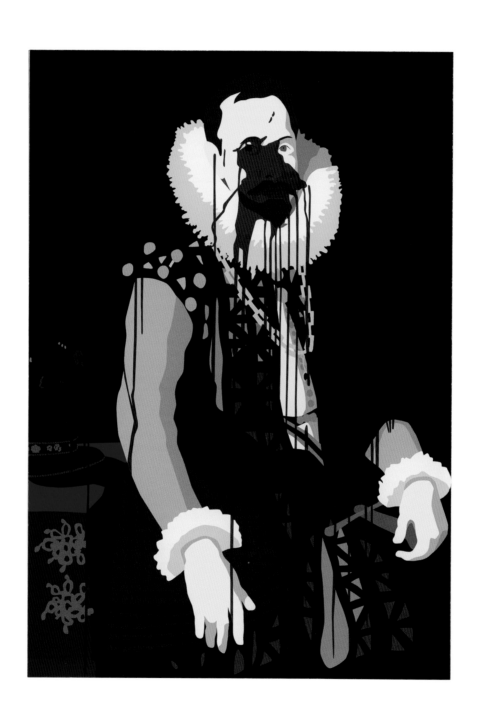

SELF-PORTRAIT WITH BLACK BERET AND GOLD CHAIN

Transparency in light box, 28 x 22 inches, 2016

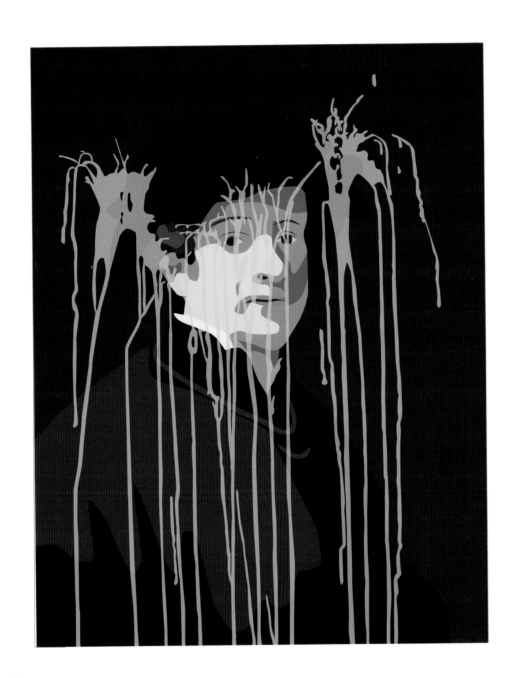

CHRONOLOGY

1793

Jacques-Louis David paints *The Death of Marat*.

1903–1907

Over a period of more than three years, Gustav Klimt paints *The Portrait of Adele Bloch-Bauer I*.

1914

The suffragette Mary Richardson walks into the National Gallery in London and attacks Velázquez's *Rokeby Venus* with a meat cleaver.

1915

D.W. Griffith directs *The Birth of a Nation*, an epic silent film set in the Civil War era. The film includes a dramatization of the assassination of President Abraham Lincoln.

1938–1945

Arthur Fellig, also known as Weegee, works as a newspaper reporter in New York. He maintains a darkroom in the trunk of his car to expedite getting his photographs of crime scenes to the newspapers.

1941

In Vienna, the assets of Ferdinand Bloch-Bauer, including *The Portrait of Adele Bloch-Bauer I*, are seized by the Nazi government.

1963

Abraham Zapruder, a bystander watching the motorcade of John F. Kennedy in Dallas, records the assassination of the president with an 8mm film camera.

1964

Andy Warhol creates *Thirteen Most Wanted Men*, a large mural for the New York State Pavilion at the World's Fair in Flushing Meadows, New York.

1970

A bomb placed on a pedestal irreparably damages the Cleveland Museum of Art's version of Rodin's *The Thinker*.

1974

A surveillance camera records newspaper heiress Patty Hearst participating in an armed robbery with the Symbionese Liberation Army of the Hibernia Bank in San Francisco.

1975

William de Rijk, an unemployed schoolteacher, uses a knife to cut dozens of zigzag lines into Rembrandt's *Night Watch* at the Rijksmuseum in Amsterdam.

1977–1988

Serial vandal Hans-Joachim Bohlmann damages over 50 paintings worth approximately 130 million euro by artists such as Rubens, Rembrandt and Dürer.

1987

A magazine reporter finds and photographs German politician Uwe Barschel dead and fully clothed in the bathtub of his room at the Hotel Beau-Rivage in Geneva.

1990

Two men posing as police officers steal thirteen works of art valued at $500 million from the Isabella Stewart Gardner Museum in Boston.

1995

At the Los Angeles County Superior Court, O.J. Simpson is found not guilty on two counts of murder by a jury in a trial spanning eleven months.

2001–2002

Kota Ezawa draws *The Simpson Verdict*, a 3-minute animation based on the TV broadcast of the trial.

2004–2006

Ezawa digitally paints a series of images titled *The History of Photography Remix*. It includes re-creations of photographs by Weegee and surveillance footage of the Hibernia Bank Robbery.

2005

Kota Ezawa draws *The Unbearable Lightness of Being*, an animation depicting the assassinations of Abraham Lincoln and John F. Kennedy as they are seen in D. W. Griffith's *The Birth of a Nation* and the Zapruder Film.

2006

The Wrong Gallery presents *Down By Law*, an exhibition about the dark side of American culture and outlaws at the 2006 Whitney Biennial. The show includes Kota Ezawa's *The Unbearable Lightness of Being*.

2006

Austria returns Gustav Klimt's painting Portrait of *Adele Bloch-Bauer I* to Maria Altman, the niece of Ferdinand Bloch-Bauer after a 7-year lawsuit. In the same year the painting is sold to Ronald Lauder who displays it at Neue Galerie in New York City.

2010

Musée d'art moderne de la ville de Paris reports the overnight theft of paintings by Pablo Picasso, Henri Matisse, Georges Braque, Amedeo Modigliani and Fernand Léger.

2017

The Mead Art Museum at Amherst College exhibits Kota Ezawa's light box installation *Gardner Museum Revisited* in its historic Rotherwas Room.

2017

SITE Sante Fe presents a solo exhibition of Kota Ezawa's oeuvre *The Crime of Art*.

ACKNOWLDGMENTS

Thank you to: SITE Santa Fe, Mead Art Museum, Haines Gallery, Christopher Grimes Gallery, and Paulson Fontaine Press for their generous support that made this book possible; Irene Hofmann and David Little for organizing the exhibition; Jordan Kantor and Niko Vicario for their excellent writing contributions; David Chickey for his artful design; Megan Mulry and Montana Currie of Radius Books for their enthusiasm and diligence; Ryan Thayer for his meticulous drawing assistance; Murray Guy and Galerie Anita Beckers for showing and promoting the work; and Jana Ezawa for her indispensable feedback and encouragement.

This publication was made possible through generous contributions from the following:

SITE Santa Fe
Mead Art Museum
Haines Gallery
Christopher Grimes Gallery

Dee Dee & Rick Chesley
Shaari Ergas
Nion McEvoy
Judy Schulich

RADIUS BOOKS

is a tax-exempt 501(c)(3) nonprofit organization whose mission is to encourage, promote, and publish books of artistic and cultural value. We believe that the arts play a significant role in society and that books can expand and effectively enhance great artistic vision.

SITE SANTA FE

is one of the premier contemporary art museum's in the Southwest, and nurtures innovation, discovery, and inspiration through the art of today. Since its opening in 1995, the museum has been committed to supporting new developments in contemporary art, encouraging artistic exploration, and expanding traditional museum experiences. SITE's year-round schedule of exhibitions serves as a platform for experimental curatorial approaches, innovative exhibition design, and projects by emerging and established artists.

MEAD ART MUSEUM

is named for its founder, William Rutherford Mead (an 1867 graduate of Amherst College and a partner in the storied architectural firm of McKim, Mead & White), and holds the art collection of Amherst College, celebrated for its holdings. The museum is situated in the vibrant Five Colleges academic community of western Massachusetts, and serves as a laboratory for interdisciplinary research and innovative teaching involving original works of art.

RADIUS BOOKS
227 E. Palace Ave., Suite W
Santa Fe, NM 87501
t: (505) 983-4068 radiusbooks.org

Available through

D.A.P. / DISTRIBUTED ART PUBLISHERS
75 Broad Street, Suite 630
New York, NY 10004
t: (212) 627-1999 artbook.com

ISBN 978-1-942185-32-1

Library of Congress Cataloging-in-Publication Data available from the publisher upon request.

DESIGN: David Chickey
PROOF-READING: Kelli Rae Patton
PRE-PRESS: ALTA

Printed by Editoriale Bortolazzi-Stei, Verona, Italy

JACKET: Detail of *Munch Theft*, Digital Drawing, 2017